The Moon Over the Mountain

Atsushi Nakajima + Nekosuke

"The Moon Over the Mountain"
first appeared in the magazine *Bungakukai* in February of 1942

ATSUSHI NAKAJIMA

Born in Tokyo in 1909, Nakajima graduated from Tokyo Imperial University and worked as a teacher before being sent to Palau on government business. He died of asthma at the age of 33. His famous works include "The Moon Over the Mountain," *Light, Wind, and Dreams*, and "Li Ling."

Illustrations: NEKOSUKE

Originally from Tottori Prefecture, Nekosuke illustrates book covers, games, CD jackets and more. Publications include *Soirée: Collected Artworks* and *Red Dragonfly* (by Nankichi Niimi).

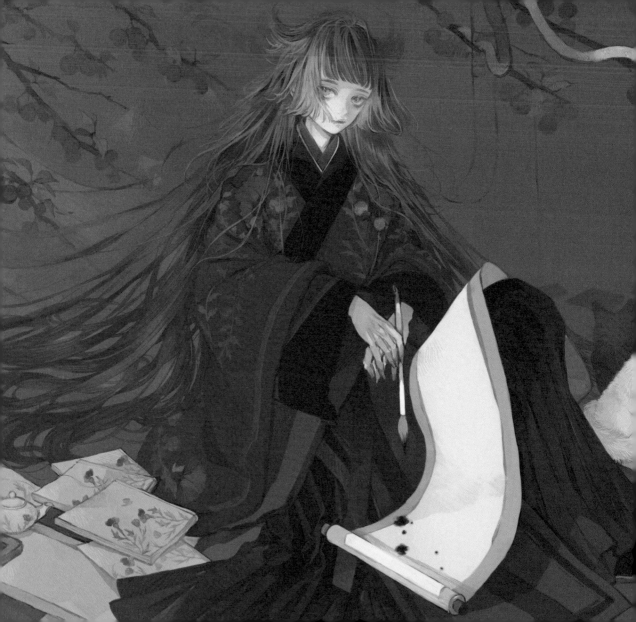

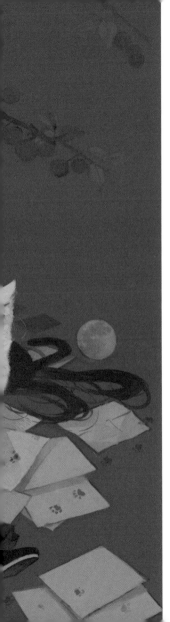

Li Zheng of Longxi, a brilliant and promising young man, passed the civil service examination in the last years of the Tianbao era and was appointed to a post in Jiangnan. Being naturally self-centered and proud, however, he found that life as a bureaucrat fell short of the ambitions he had for himself, and before long, he resigned and returned to his home in Guolue. There he holed up and threw himself into composing verse. Instead of lowering himself to doing the bidding of an unworthy superior, he thought, he would make an immortal name for himself as a poet. But his big break never came, and in the meantime, he had to eat. Li Zheng felt that he was running out of time.

He started to look increasingly haggard. He lost weight, his bones showing through his skin, while his eyes took on a strange glitter. He was unrecognizable as the rosy-cheeked young man who'd made such an auspicious start to his career.

After a few more years of straitened circumstances, he finally gave in and took up a provincial post out east in order to provide for his wife and children. He'd also more or less given up on the idea of making his name as a poet. In the years he'd been away, his former peers had been elevated to high stations, and it's easy to imagine how it must have chafed to take orders from people he'd dismissed as dullards back when he was a rising star. He sulked and brooded, his behavior becoming more and more erratic and antisocial.

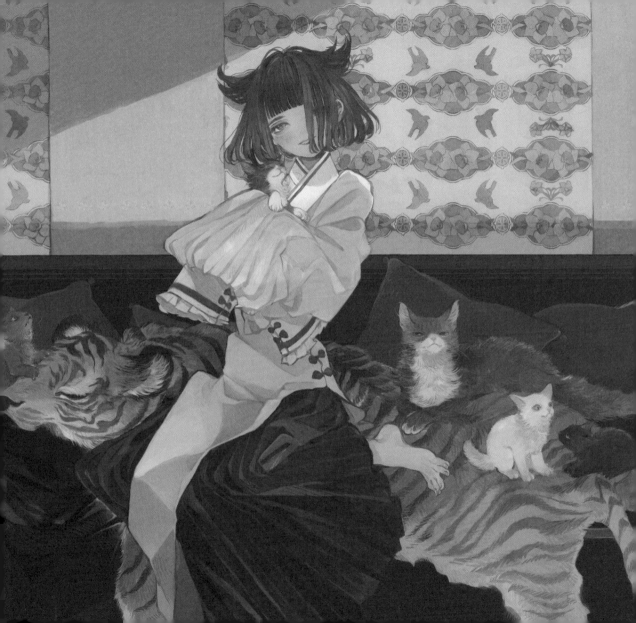

One year into the new job, he had been sent to a place on the banks of the Rushui when he finally snapped. In the middle of the night, he leapt out of bed with a wild look in his eyes and ran off into the darkness, screaming incoherently. That was the last anyone saw of Li Zheng. No trace of him was found in the surrounding countryside, and no one could discover what had become of him.

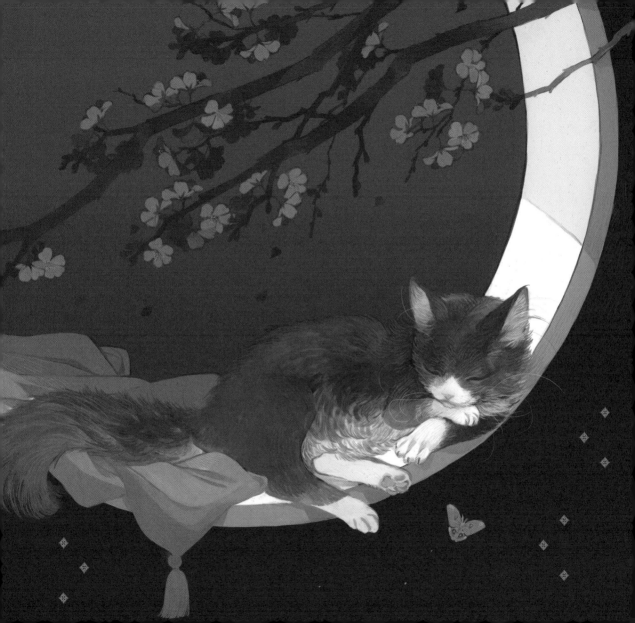

The following year, Yuan Can of Chenjun, a high-ranking government inspector, was dispatched to Lingnan, and along the way he stopped at Shangyu. When he rose before dawn the next day to continue on his journey, the innkeeper told him, "A man-eating tiger roams the road ahead, and travelers are only safe in broad daylight. Wait for morning before you set off." Yuan Can was traveling with a sizable retinue, however, and feeling confident that they would keep him safe, he ignored the innkeeper's suggestion and set off without delay.

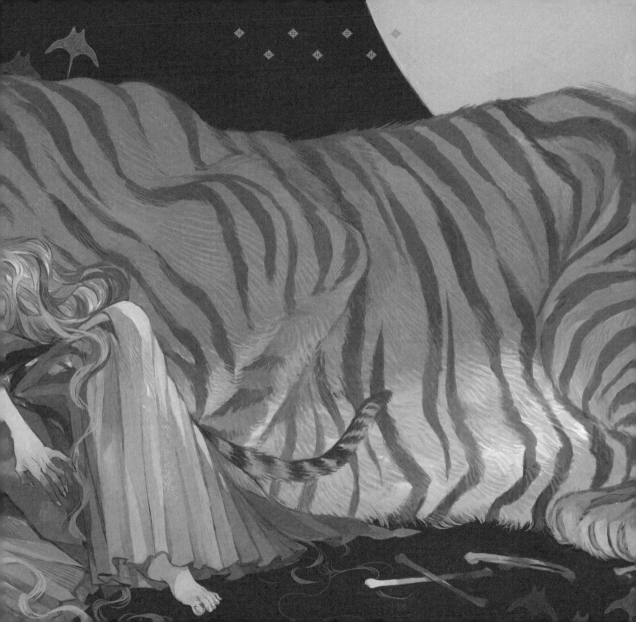

As the party made their way across a clearing in the woods by the last light of the moon, a fearsome tiger leapt out from the tall grass, just as the innkeeper had warned. The tiger seemed to be on the verge of attacking Yuan Can, when at the last second it turned around and disappeared back from where it had come.

"That was a close call," a human voice muttered from the thicket. "That was a close call."

Yuan Can was sure he'd heard the voice before, and even in his fright, he managed to place it.

"Is that you, Li Zheng, old friend?" he cried.

Yuan Can had passed the civil service examination the same year as Li Zheng, and had once been his closest friend. His gentle personality had accommodated Li Zheng's prickly disposition when few others would.

For a while, there was no reply—only the occasional faint sound of someone trying to hold in sobs. At last, a low voice said, "Indeed, it is I—Li Zheng of Longxi."

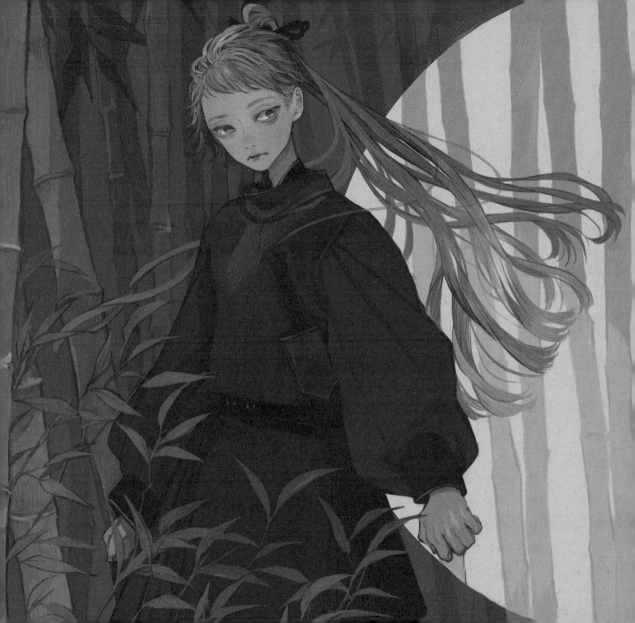

Yuan Can forgot his fear, and, dismounting his horse, approached the thicket. "Come out and talk to me, friend," he said. "Why won't you show yourself?"

"I am no longer the man you remember," came Li Zheng's reply. "I can't bear for you to see what I've become. And more importantly, I should spare you the alarm and disgust that my new appearance provokes. But the joy of meeting you again so unexpectedly almost makes me forget my shame. Might you stay a little while and talk with your old friend, despite his hideous new form?"

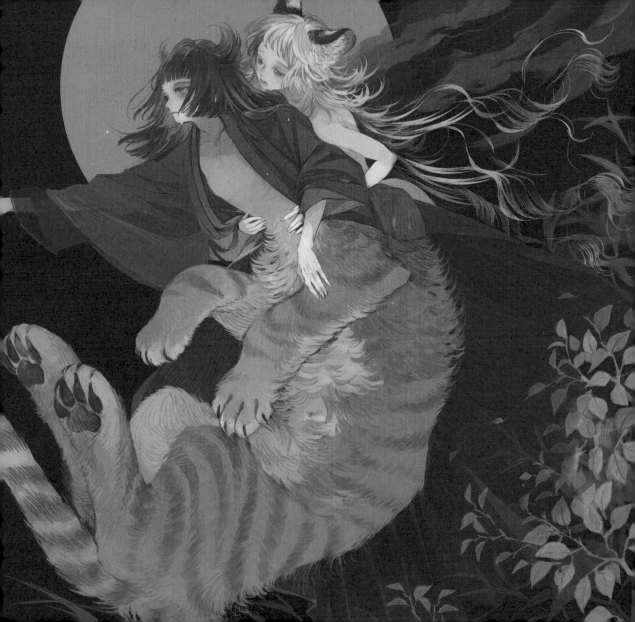

Looking back later he found it strange, but in that moment, Yuan Can was unperturbed by this extraordinary development; he took the whole thing in stride. Telling his retinue to halt, he went to stand beside the thicket and converse with the unseen voice. They spoke of the gossip in the capital and the latest news about their friends. Yuan Can told Li Zheng of his prestigious new post, at which Li Zheng expressed his congratulations. Once they'd covered these topics in the frank manner of two friends who had known each other when they were young, Yuan Can asked Li Zheng what had happened to him.

"Around a year ago, I came to this region and lodged by the banks of the Rushui. I fell asleep, and awoke to a voice calling my name from outside the inn. I followed it to find that it was coming from the darkness, and I raced off after it as though I was in a trance. Before I knew it, the road had led me into the woods, and I was clawing at the ground with my fingers as I ran. I was full of a strange strength, and leapt easily over the rocks in my path. After a while I noticed fur had sprouted down my forearms and over my hands.

"Once it got light, I found a mountain stream and stopped to look at my reflection, only to find a tiger looking back at me. At first I couldn't believe my eyes. Then I thought I must be dreaming—I'd had dreams before where I'd known I was in a dream. But eventually I had to accept that I was awake. I felt numb, then terrified. I experienced a profound fear at the realization that truly anything was possible. How had this happened? It was beyond me. How could any of us know anything at all? We're all just dumb animals, saddled with a life we didn't ask for, sentenced to exist without a reason for living. I longed for death. Just then, a hare ran across the clearing. The human in me winked out, and when I came to again, tufts of fur littered the grass around me and my mouth was sticky with blood.

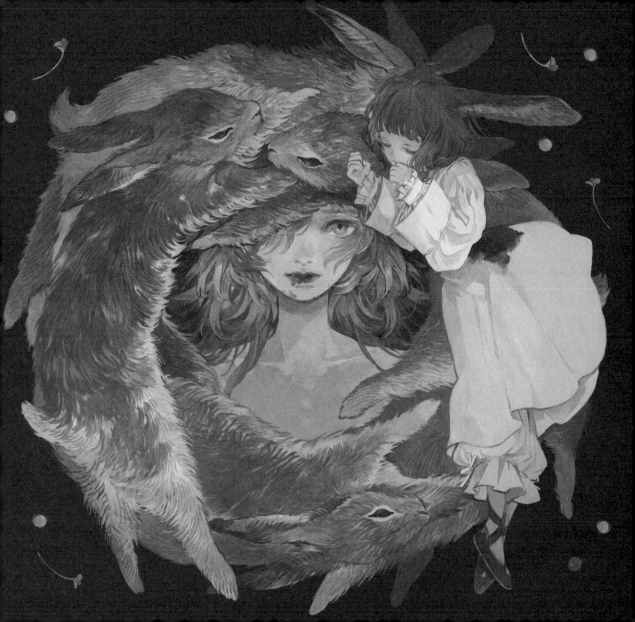

"That was the tiger's first kill.

"I cannot bear to confess to you the things I've done since. I have a few precious hours each day when my humanity resurfaces, when I can think and speak and quote from the classics once again. But then I'm confronted by the evidence of my own savage acts, and in being forced to face up to my terrible fate, I've never felt more miserable, frightened, angry... With each passing day, though, I have less and less time as myself. Where I used to wonder what I'd done to deserve being turned into a tiger, now I sometimes catch myself wondering why I was human before.

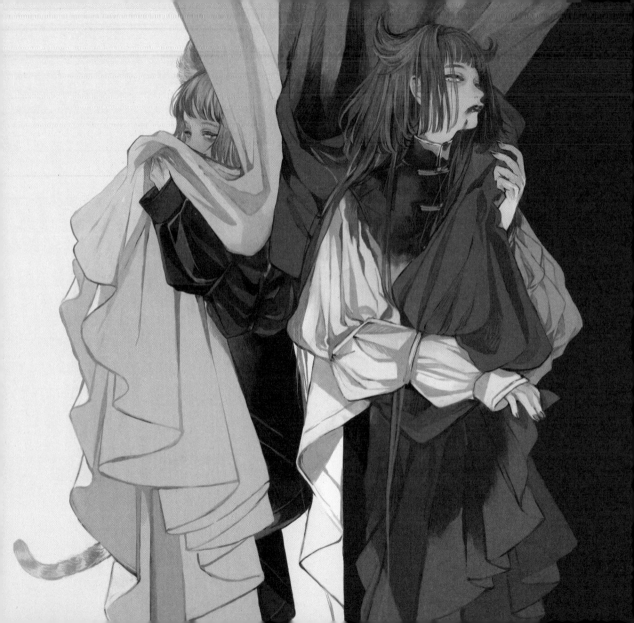

"It frightens me. Soon enough, my humanity will be lost forever, buried under these brutish habits like the foundations of a ruined castle swallowed up by the earth. Then I'll forget who I once was; I'll prowl these parts, feral, and if I see you on this road again I won't know you as a friend, but rend you limb from limb, devour you, and feel nothing.

"I think all of us, whether beast or human, were something else once. Maybe we remember at first, but over time we forget, and believe ourselves to have always been the way we are now... But what difference does it make? No doubt I'll be happier once the human part of me is gone completely, though the man in me dreads that more than anything. Aah, I can't tell you how terrible and lonely and hopeless it makes me feel, the idea of forgetting I was human! You can't possibly understand. No one can... I'm alone with this. But before my humanity is lost entirely, I have one request to make of you."

Yuan Can and his retinue listened, transfixed, to this incredible story. The voice went on:

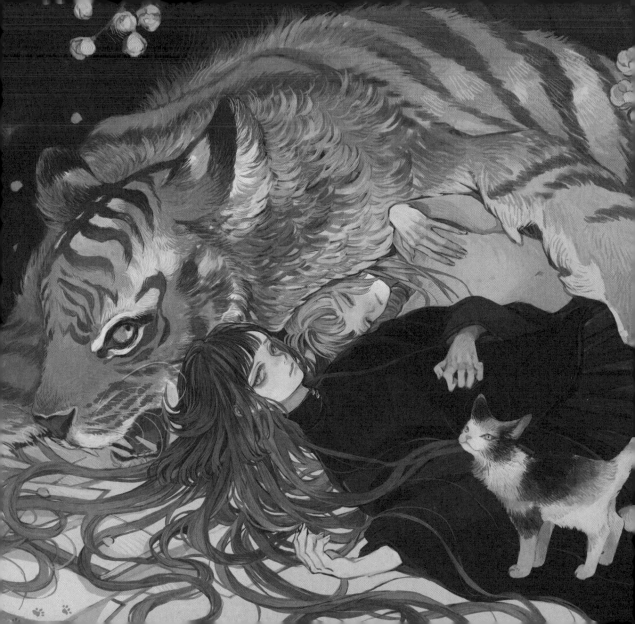

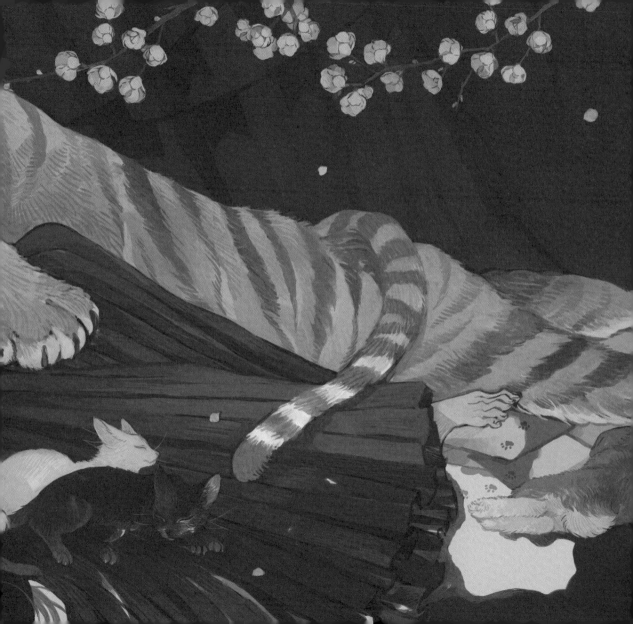

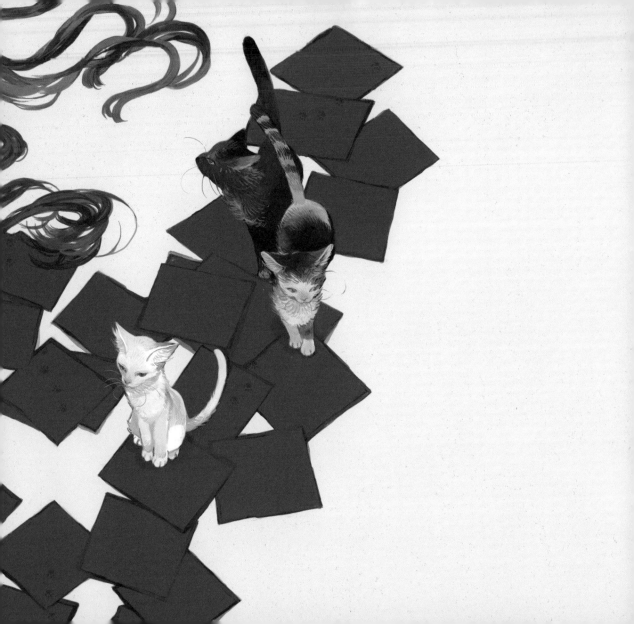

"I dreamed of being known for my poetry; and yet look at me now. No one has read the hundreds of poems I wrote. The manuscripts have probably been lost or destroyed. But I still know a few dozen by heart. Will you copy them down for me? I'm under no illusion that this will make me a proper poet, of course. But their literary value aside, I ruined my life and sacrificed my sanity for poetry, and I can't die without passing on at least a few lines of my own."

Li Zheng's voice rang out clearly from the tall grass, and Yuan Can told one of his attendants to write down everything he said. He recounted more than thirty poems of varying lengths, stylish and elegant, clever and refined, each inspiring admiration and attesting to the writer's uncommon ability. At the same time, Yuan Can had the uneasy impression that while his friend's talent was clearly of the highest order, there was something lacking in these poems—something hard to describe—which kept them from being true works of art.

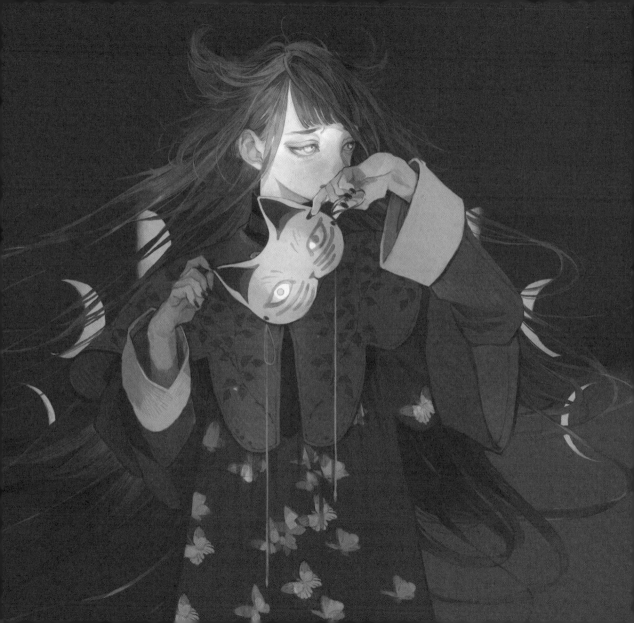

When he had finished reciting his old poems, Li Zheng turned suddenly self-deprecating. "It pains me to admit it, but even in this debased form I still sometimes picture men of taste in the capital leafing through a volume of my poetry. What a thing to dream of as I lie in a mountain cave! Go ahead and laugh. I'm a pathetic man who thought he could be a poet, but only ended up as a tiger." (Yuan Can listened with a heavy heart, remembering how Li Zheng had always been hard on himself, even in his youth.) "Anyway, as long as I'm giving you something to laugh about, let me try my hand at extemporizing a poem for the occasion. Just to prove there's something left of me under all this godforsaken fur."

Yuan Can told his attendant to write this down, too.

By a twist of nature, cruelly transformed
Caged by calamity and inescapable fate
My teeth and claws keep the world at bay
We were friends once, esteemed in equal measure
Now you ride forth in a palanquin
While I am a beast skulking in the weeds
The moon shines over the mountains tonight
Yet I cannot sing its praises; I can only howl

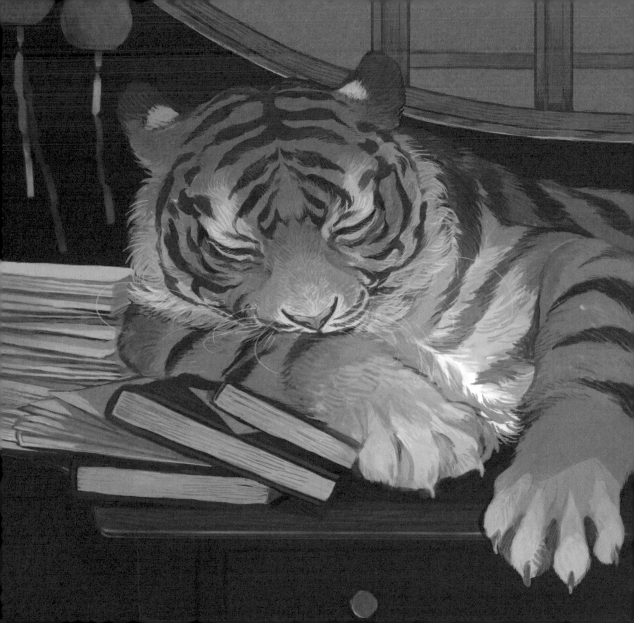

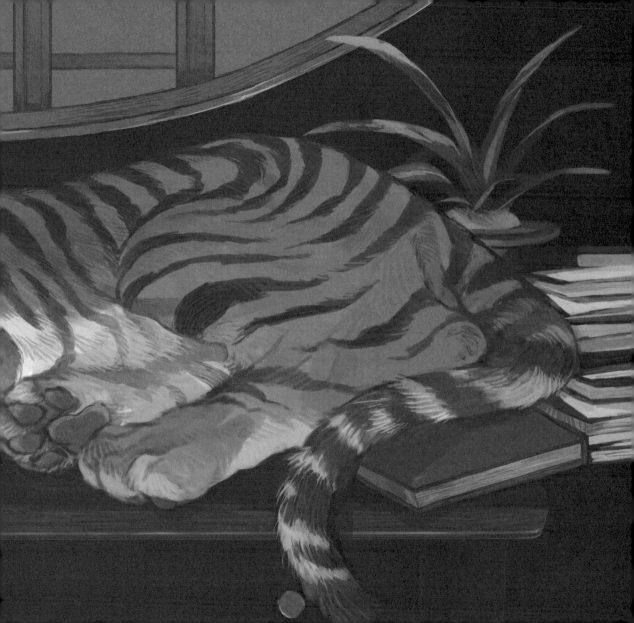

The cold light of the fading moon, the glistening dew blanketing the ground, and the chill wind through the trees announced the approach of dawn. Yuan Can and his retinue forgot all about the bizarreness of the situation, and in the hush following Li Zheng's words they were left with nothing but solemn compassion for the unfortunate poet.

"I know I said earlier that I don't know how this happened," Li Zheng continued. "But as I ponder it, there is one thing that comes to mind. Back when I was human, I went out of my way to avoid others. People said I was arrogant and snobbish. What they didn't understand was that I was simply insecure. I took pride in my reputation as a prodigy back home, of course. But even that was the pride of a coward. I told everyone I wanted to be a poet, but I never sought out a teacher to learn from, or found other scholars with whom to hone my craft. At the same time, I told myself I was better than the rabble and held myself apart from them. All this was to protect my cowardly ego, my narcissistic shame.

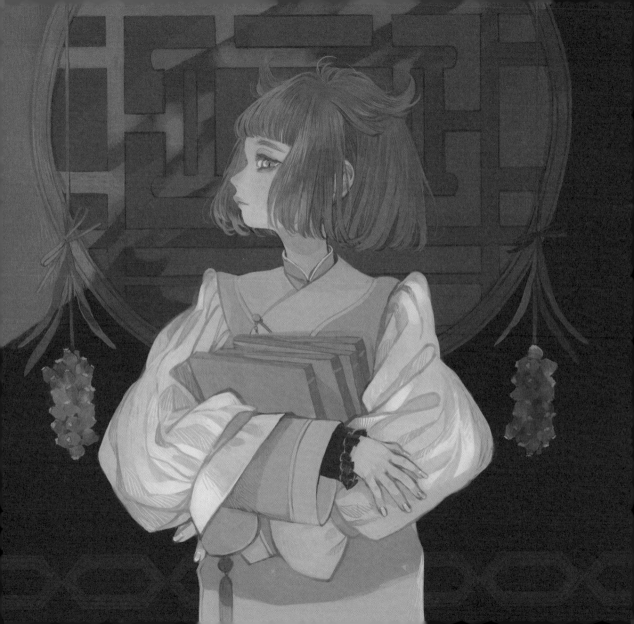

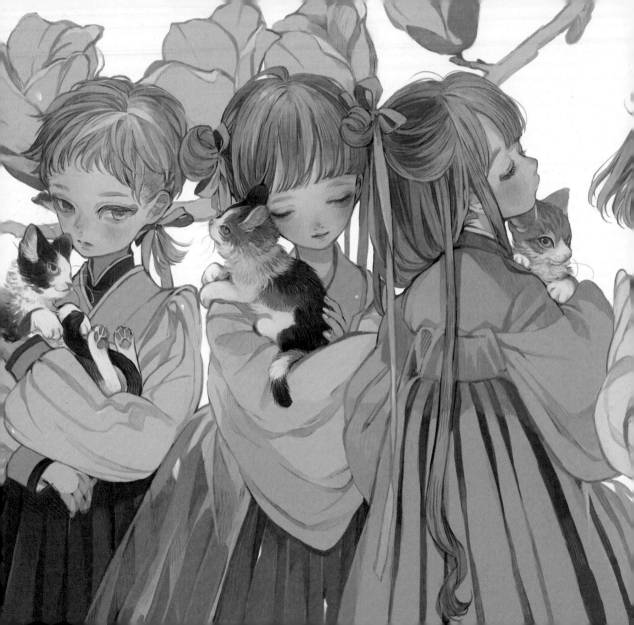

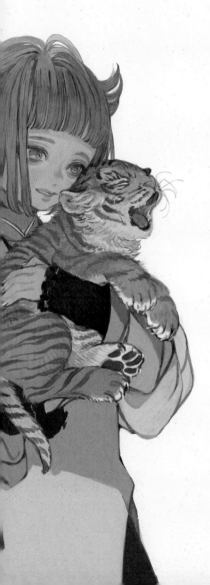

"Out of fear that I might turn out not to be a genius, I hesitated to polish the uncut gemstone of my own potential; but, convinced that I had a gift, I was not content to remain in the rough. Over the years, I shut myself off from society, alienated myself from the people around me, and fed my cowardly ego with resentment and rage until it was bursting at the seams. Each of us has an animal nature we must strive to tame. Well, this arrogant shame was my inner beast: the tiger.

"The tiger ruined me, mistreated my family, hurt my friends, and in the end transformed my outward appearance into something befitting my inner self. Now I see that I utterly wasted what little gift I had. I postured cynically, claiming that life was too long to do nothing but too short to do anything worthwhile, when in fact I was gripped by the craven anxiety that I might be revealed as an impostor, along with a shiftlessness that made me shy away from strenuous effort.

"How many people gifted with far less talent than I have turned themselves into respected poets through hard work and dedication? By the time I realized this, it was too late—I had already become a tiger. It makes me want to claw my heart out in regret. I can no longer live as a man; I could compose the finest poetry in the world, but no one would be any the wiser.

"Even worse, my mind gets more and more tigerish every day. What am I to do? What about all those years I wasted? I can hardly stand it.

"When it all gets to be too much, I climb up to the crag at the top of that mountain and howl into the empty valley. I need someone to know the anguish in my heart. I was there again last night, roaring at the moon, hoping in vain for someone to understand my suffering. But the animals that hear me only quake in fear and hide themselves away. To the mountains and forests, the moon and the dew, I'm just another lunatic tiger howling in rage. No matter how I leap into the air or throw myself to the ground, not a single person sees what I'm going through. Just like when I was a man, and no one understood how sensitive my feelings were. My fur is wet with more than just the night dew."

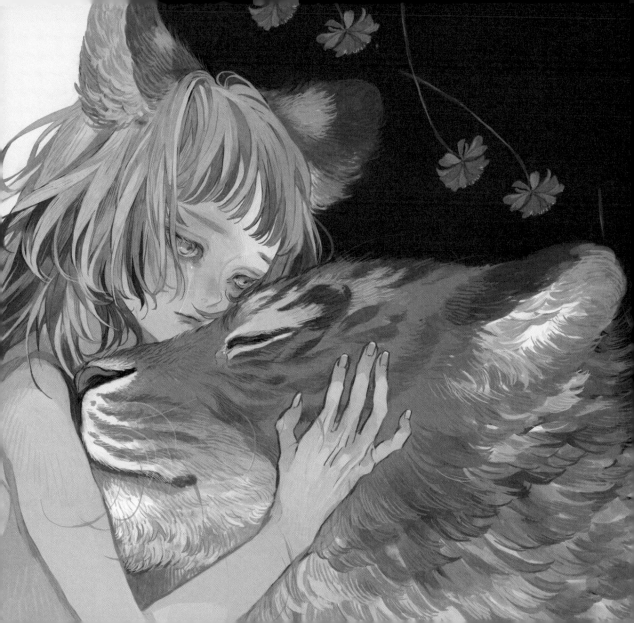

The darkness around them was finally fading, and the sound of a horn rang out plaintively from somewhere beyond the trees.

"I must take my leave. It's almost time for me to go back (to become a tiger again)," came Li Zheng's voice from out of the thicket. "But before I bid you farewell, I need to ask you one last thing. It's my family in Guolue. They have no way of knowing the truth of what's befallen me. When you return from the south, would you inform them that I'm long dead? Whatever happens, don't tell them of what transpired here today. I know it's a lot to ask, but they're alone in the world, and if you could ensure they don't end up cold and hungry on the streets, that would be the greatest kindness I could imagine."

Loud sobs came from the thicket, and Yuan Can, crying now himself, promised his friend he would do everything he asked.

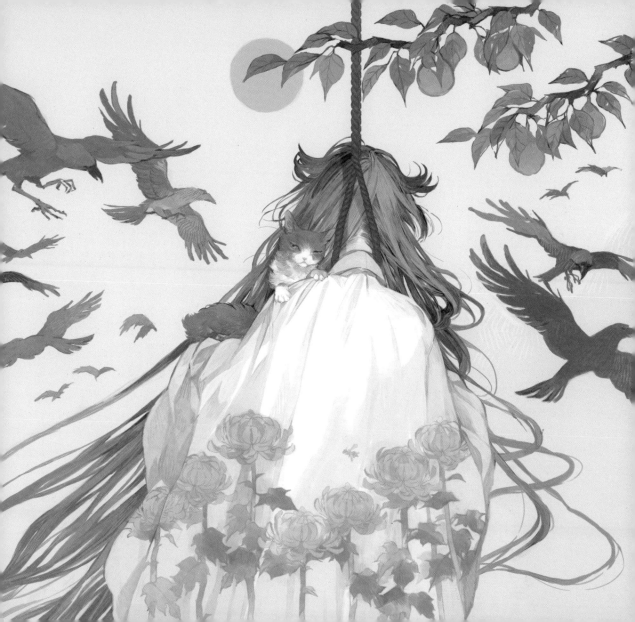

Li Zheng reverted immediately to his previous mocking tone. "I should have asked that of you first, of course, if I had a human heart," he said. "But I was the kind of man who's more concerned about his mediocre poetry than his destitute wife and children; it stands to reason, then, that I ended up in this form."

Finally, he asked Yuan Can to promise he would avoid coming this way again when he returned from Lingnan. By then he might be too far gone to know his old friend, and might attack him. After they parted, though, would Yuan Can stop at the top of the next hill and look back this way? Li Zheng would reveal himself to his friend once more—not to impress him, but simply to let his hideous form banish any lingering desire Yuan Can might have to return this way and see him again.

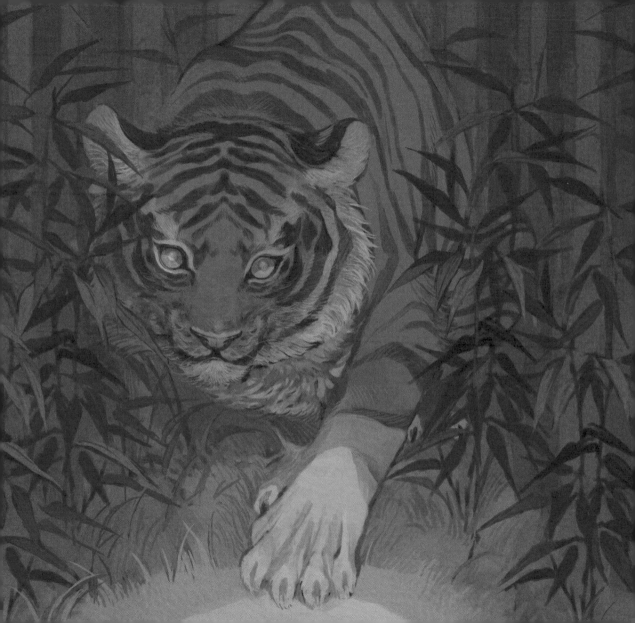

Yuan Can spoke heartfelt words of parting, then mounted his horse. Desperate, wretched sobs issued once more from within the thicket. Yuan Can rode away in tears, glancing back over his shoulder time and again.

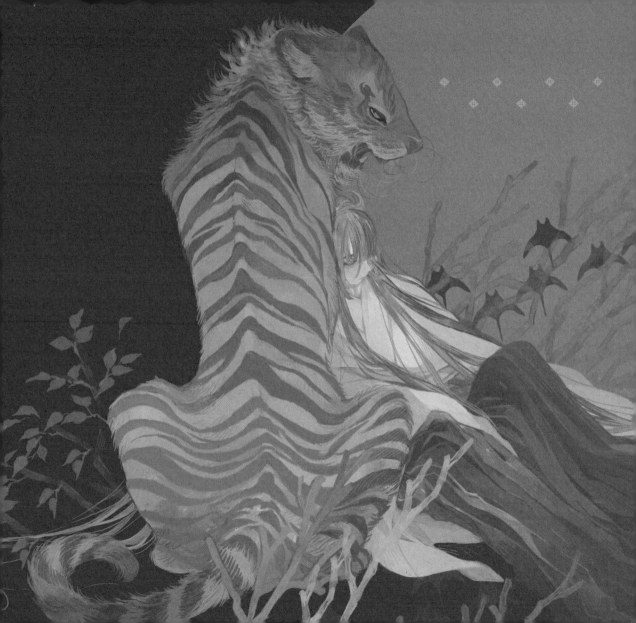

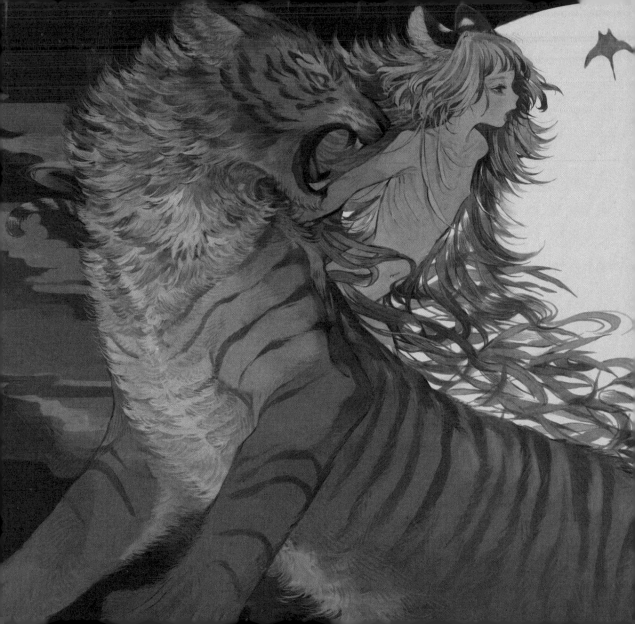

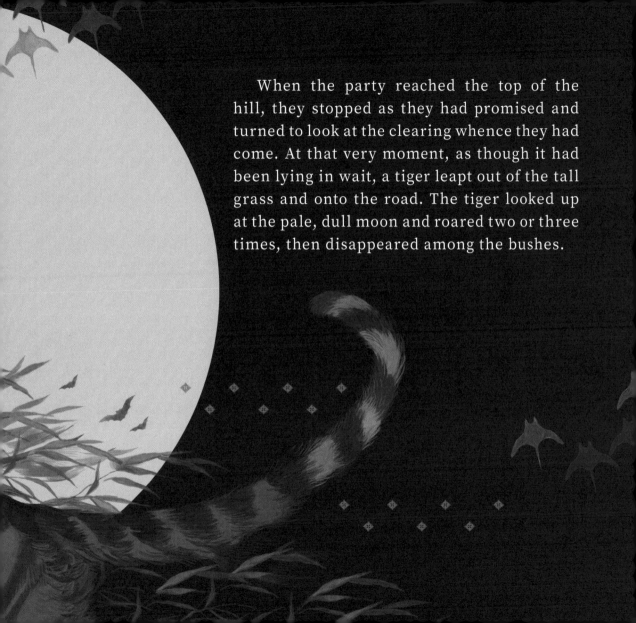

When the party reached the top of the hill, they stopped as they had promised and turned to look at the clearing whence they had come. At that very moment, as though it had been lying in wait, a tiger leapt out of the tall grass and onto the road. The tiger looked up at the pale, dull moon and roared two or three times, then disappeared among the bushes.

Classic short stories of the early 20th century, combined with gorgeous original artwork—welcome to the strange and startling world of the Maiden's Bookshelf...

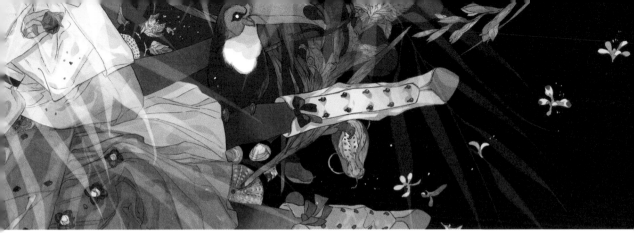

Maiden's Bookshelf

The Moon Over the Mountain

A VERTICAL Book

Editor: Daniel Joseph
Translation: Asa Yoneda
Production: Risa Cho
Proofreading: Micah Q. Allen

SANGETSUKI written by Atsushi Nakajima, illustrated by Nekosuke
Copyright © 2020 Nekosuke

This English edition published by arrangement with Rittor Music, Inc., Tokyo
in care of Tuttle-Mori Agency, Inc., Tokyo.

English language version produced by Kodansha USA Publishing, LLC, 2022

This is a work of fiction.

ISBN: 978-1-64729-179-2

Printed in the United States of America

First Edition

Kodansha USA Publishing, LLC
451 Park Avenue South
7th Floor
New York, NY 10016
www.kodansha.us

KODANSHA